T0161296

What Is
Culture For?

What Is
Culture For?

The School of Life

Published in 2018 by The School of Life
70 Marchmont Street, London WC1N 1AB
Copyright © The School of Life 2018
Printed in Latvia by Livonia Print

A proportion of this book has appeared online at
www.theschooloflife.com/thebookoflife/

Every effort has been made to contact the copyright holders of
the material reproduced in this book. If any have been
inadvertently overlooked, the publisher will be pleased to make
restitution at the earliest opportunity.

The School of Life offers programmes, publications and
services to assist modern individuals in their quest to live more
engaged and meaningful lives. We've also developed a collection
of content-rich, design-led retail products to promote useful
insights and ideas from culture.

www.theschooloflife.com

ISBN 978-0-9957535-3-2

10 9 8 7 6 5 4 3

Contents

Introduction

Our societies frequently proclaim their enormous esteem for culture and the arts. Music, film, literature, painting, photography and sculpture enjoy superlative prestige and are viewed by many as close to the meaning of life.

But our societies also have a strict sense of what properly appreciating the arts should involve. Sensible homage is associated with acquiring technical knowledge, with taking advanced qualifications in the humanities, with knowing historical details and with respecting, at least in substantial part, the canon as it is now defined.

Strangely, what we are not generally encouraged to do – and indeed what we might be actively dissuaded from attempting – is to connect works of culture with the agonies and aspirations of our own lives. It is quickly deemed vulgar, even repugnant, to seek personal solace, encouragement, enlightenment or hope from high culture. We are not, especially if we are serious, meant to view cultural encounters as opportunities for didactic instruction.

In Ben Lerner's 2011 novel *Leaving the Atocha Station*, an American PhD student, used to considering art as material for academic analyses and scholarly seminars,

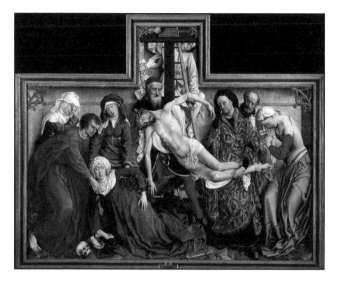

What might it be right to do in front of this?
Rogier van der Weyden,
The Descent from the Cross,
before 1443

visits Madrid's Prado museum. In one of the quieter rooms he spots a fellow visitor who moves slowly, looking intently at a range of key works, including Rogier van der Weyden's *The Descent from the Cross* (before 1443), Paolo de San Leocadio's *Christ the Saviour* (1482–4) and Hieronymus Bosch's *The Garden of Earthly Delights* (1490–1500).

What astonishes the graduate student and eventually the guards of the museum is that in front of each of these

masterpieces, the visitor doesn't merely politely look at
the caption or the guidebook; he doesn't just note the fine
brushstrokes and the azure of the skies. He bursts into
tears and cries openly at the sorrow and beauty on display,
at the contrast between the difficulties of his own life and
the spirit of dignity and nobility of the works on the wall.
Such an outburst of intense emotion is deeply unusual
in a museum (museums may routinely be referred to as
our secular cathedrals, but they are not – as cathedrals
once were – intended to be places to reveal our grief and
gratitude). Listening to the man's sobs, the guards at the
Prado grow understandably confused and nervous. As the
author puts it, they cannot decide whether the man was:

> perhaps the kind of man who would damage a painting,
> spit on it or tear it from the wall or scratch it with a
> key – or if the man was having a profound experience
> of art... What is a museum guard to do...? On the one
> hand, you are a member of a security force charged
> with protecting priceless materials from the crazed...
> on the other hand...if your position has any prestige
> it derives precisely from the belief that [great art]
> could legitimately move a man to tears... Should [the
> guards] ask the man to step into the hall and attempt to
> ascertain his mental state... or should they risk letting

this potential lunatic loose among the treasures of their culture...?

The dilemma points with dry humour to the paradox of our contemporary engagement with culture: on the one hand, we insist on culture's importance. On the other, we limit what we are meant to do with culture to a relatively polite, restrained and principally academic relationship, at points frowning on those who might treat it more viscerally and emotionally, as if it might be a sophisticated branch of the notorious category 'self-help'.

This resistance, however well meant, nevertheless fails to notice that the great works of culture were almost invariably created to redeem, console and save the souls of their audiences. They were made, in one way or another, with the idea of changing lives. It is a particular quirk of modern aesthetics to sideline or ignore this powerful underlying ambition, to the point where to shed tears in front of a painting depicting the death of the son of God may put us at risk of ejection from a national museum.

Yet the power of culture arguably best emerges not when we conceive of it as an object of critical study or historical curiosity, but when we rely on it as a therapeutic tool that

Great works
of culture
were almost
invariably
created to
redeem, console
and save the
souls of their
audiences.

can be used in a quest to grow somewhat less isolated, frightened, shamed, restricted or skittish. Rather than focus on what a work of art might tell us about the time and place it was made or about the person who created it, we should develop the confidence to do exactly that which we might feel discouraged to do: relate cultural masterpieces to our own dilemmas and pains, using them as a resource with which to address a range of our most debilitating and pernicious agonies.

Companionship

The greatest share of art that humans have ever made for one another has had one thing in common: it has dealt, in one form or another, with sorrow. Unhappy love, poverty, discrimination, anxiety, sexual humiliation, rivalry, regret, shame, isolation and longing; these have been the chief constituents of art down the ages.

However, we are, in public discussion, often unhelpfully coy about the extent of our grief. The chat tends to be upbeat or glib; we are under awesome pressure to keep smiling in order not to shock, provide ammunition for enemies or sap the energy of the vulnerable.

We thereby end up not only sad, but sad that we are sad – without much public confirmation of the essential normality of our melancholy. We grow harmfully stoic or convinced of the desperate uniqueness of our fate.

All this, culture can correct – standing as a record of the tears of humanity, lending legitimacy to despair and replaying our miseries back to us with dignity, shorn of many of their haphazard or trivial particulars. 'A book [though the same could be said of any art form] must be the axe for the frozen sea within us,' proposed Kafka in a 1904 letter to his friend Oskar Pollak. In other words, a

tool that can help release us from our numbness and provide catharsis in areas where we have for too long been wrong-headedly brave.

There is relief from our submerged sorrows to be found in all of history's great pessimists. For example, in the words of Seneca from his *On Consolation to Marcia* (c. 40 AD):

> What need is there to weep over parts of life? The whole of it calls for tears.

Or the ironic maxims of Schopenhauer in *The World as Will and Representation* (1818):

> There is only one inborn erroneous notion...that we exist in order to be happy.... The wise know it would have been better never to have been born.

Such pessimism tempers prevailing sentimentality. It provides an acknowledgement that we are inherently flawed creatures: incapable of lasting happiness, beset by troubling sexual desires, obsessed by status, vulnerable to appalling accidents and always – slowly – dying.

Life is sorrow
Anselm Kiefer,
Alkahest,
2011

This vast painting (nearly four metres across) by Anselm Kiefer is – unlike the normal habits of our society – extremely forthright about the essentially sorrowful character of the human condition. Everything we love and care about will come to ruin, all that we put our hope in will fail. In a note to the painting, Kiefer writes: Even 'rock that looks as though it will last for ever is dissolved, crushed to sand and mud'. The dramatic scale is not accidental: it's a way of trying to make obvious something that is often repressed and ignored: dejection, sadness

and disappointment are major parts of being human. The work's icy, grey, harsh character summons up equally grim thoughts about our own lives.

It's not an intimate picture because the fact Kiefer is asserting isn't a personal one: it's not so much we who are unduly down, it is life itself which demands a melancholy response. He's not attempting to delve into the unique painful details of our individual sorrows. The painting isn't about a relationship that didn't work out, a friendship that went wrong, a dead parent we never fully made peace with, a career choice that led to wasted years. Instead it sums up a feeling and an attitude: lonely, lost, cold, worried, frightened. And instead of denying these feelings as worthy only of losers, the work proclaims them as important, serious and worthy. It is as if the picture is beaming out a collective message: 'I understand, I know, I feel the same as you do, you are not alone.' Our own private failings and woes – which may strike us as sordid or shameful or very much our own fault – are transformed; they are the personal way in which a tragic theme of existence happens to play out in our own lives. They are, in fact, ennobled, by their kinship to this grand work. It is like the way a National Anthem works – by singing it the individual feels themselves part of a great community,

they are strengthened, given confidence, they can see themselves as strangely heroic, irrespective of their circumstances. Kiefer's work is like a visual anthem for sorrow, one that invites us to see ourselves as part of the nation of sufferers, which includes, in fact, everyone who has ever lived.

Jean-Baptiste Corot described his painting *The Leaning Tree Trunk* as a souvenir or memory. It is filled with the idea of farewell. The moment will pass, light will fade, night will fall. The years will disappear, we will wonder what we did with them. Corot was in his late sixties when he painted this work: the mood is elegiac, mourning what has gone and will never come back. Ultimately, it is a farewell to life but it is not a bitter or a desperate one. The mood is resigned, dignified and, although sad, accepting. Our own personal grief at the passing of our lives (if not soon, then someday – but always too soon) is set within a much wider context. A tree grows, it is bent and twisted by fate and eventually will dry up and wither, like that on the lefthand side of the painting. The sunlight illuminates the sky for a while and then is hidden behind the clouds and night descends. We are part of nature. Corot isn't glad that the day is over, that the years have gone and that the tree is dying, but his painting seeks to instil a mood of sad

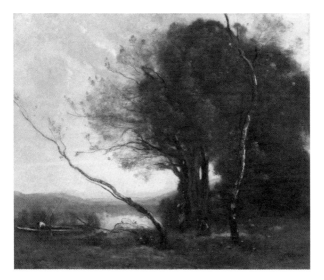

Our lives too will pass and fade, like this moment
Jean-Baptiste Corot,
The Leaning Tree Trunk,
c. 1860–65

yet tranquil acceptance of our own share in the fate of all living things.

This is a move we encounter repeatedly in the arts: other people have had the same sorrows and troubles that we have, and it isn't that they don't matter, or that we shouldn't have them, or that they aren't worth bothering about. What counts is how we perceive them. By interacting with art, we encounter the spirit or voice of

someone who profoundly sympathises with suffering, but who allows us to sense that through it, we're connecting with something universal and unashamed. We are not robbed of our dignity: we are discovering the deepest truths about being human – and therefore we are not degraded by sorrow but, strangely, elevated.

We can feel this elevation through sorrow especially in the presence of 'sad' music. One of the most calming things that societies have ever devised is the lullaby. In almost every culture there has ever been, parents have sung their babies to sleep. A humbling point that a lullaby reveals is that it's not necessarily the words of a song that make us feel more tranquil. The baby doesn't understand what's being said but the sound has its effect all the same. The baby shows that we are all tonal creatures long before we are creatures of understanding. As adults, we grasp the significance of words of course, but there remains a sensory level that cuts through and affects us far more than an argument or an idea ever could. The musician can, at points, trump anything the philosopher might tell us.

Ancient Greeks were fascinated by the story of the legendary musician Orpheus. At one point he had to rescue his wife from the underworld. To get there he needed to

make his way past Cerberus, the ferocious three-headed dog that guarded the entrance to the land of the dead. Orpheus was said to have played such sweet, enchanting music that the wild beast calmed down and became – for a while – mild and docile. With this myth, the Greeks were reminding themselves of the psychological power of music. Orpheus didn't reason with Cerberus, he didn't try to explain how important it was that he should be allowed to pass, he didn't speak about how much he loved his wife and how much he wanted her back. Cerberus was – as we ourselves are at times of distress – pretty much immune to reason. But he was still open to influence. It was a matter of finding the right channel to reach him.

When we feel anxious or upset, kindly people sometimes try to comfort us by pointing to facts and ideas: they try to influence our thinking and – via careful arguments – to quieten our distress. But, as with Cerberus, the most effective way to deal with sorrow may simply be to play us music.

For instance, in Schubert's 'Ave Maria' (composed in 1825) we feel enfolded in a generous, tender embrace, encountering no criticism or rebuke, but endless depths of understanding and compassion for our troubles.

The music lifts us up and gently distracts us from any immediate cause of agitation, as a parent might try to distract an upset child. Peter Gabriel's 'Don't Give Up' (1986) is designed as a similar kind of musical therapy. It's intended for those times when we do feel like giving up, when we've lost all confidence and feel crushed by the demands of the world. The strategy is to be as sympathetic as an imagined mother: first to acknowledge the horribly painful sense of failure and then to offer a kindly reassurance. The message is not that our plans will inevitably work out, but that our human worth is not on the line if they don't. The music offers us what at such points we can't offer ourselves: compassion and faith.

Between 1733 and 1749, J. S. Bach produced his Mass in B minor, perhaps the greatest musical axe ever to be brought to bear on that frozen sea within us. Near the beginning there is the 'Kyrie': a call to the congregation to recognise the ways they've hurt and wronged others, and a plea that God will forgive their unkindness. A five-voice fugue theme (soprano I, II, alto, tenor, bass) and a step-wise ascending melody, interrupted by a lower sighing motive, encourage us to feel repentance about our own failings while hinting at the eventual certainty of redemption.

Not only are we sad, we are also, most of us, lonely with what saddens us. We can imagine ourselves as a series of concentric circles. On the outside lie all the more obvious things about us: what we do for a living, our age, education, tastes in food and broad social background. We can usually find plenty of people who recognise us at this level. But deeper in are the circles that contain our more intimate selves, involving feelings about parents, secret fears, daydreams, ambitions that might never be realised, the stranger recesses of our sexual imagination and all that we find beautiful and moving.

Though we may long to share the inner circles, too often we seem able only to hover with others around the outer ones, returning home from yet another social gathering with the most sincere parts of us aching for recognition and companionship. Traditionally, religion provided an ideal explanation for, and solution to, this painful loneliness. The human soul – religious people would say – is made by God and so only God can know its deepest secrets. We are never truly alone, because God is always with us. In their touching way, religions had identified an important problem: they recognised the powerful need to be intimately known and appreciated and admitted frankly that this need could not realistically ever be met by other people.

Religion has been replaced in our imaginations by the cult of human-to-human love we now know as Romanticism, which bequeathed to us a beautiful, reckless idea that loneliness might be capable of being vanquished, if we were fortunate and determined enough to meet the one exalted being known as our soulmate, someone who could understand everything deep and strange about us, who would see us completely and be enchanted by our totality. But the legacy of Romanticism has been an epidemic of loneliness, as we are repeatedly brought up against the truth: the radical inability of any one other person to wholly grasp who we truly are. Yet there remains, besides the promises of love and religion, one other – and more solid – resource with which to address our loneliness: culture.

Henri Matisse began painting people reading in his early twenties and continued to do so throughout his life; at least thirty of his canvases tackle the theme. What gives these images their poignancy is that we recognise them as records of a loneliness that has been at least in part redeemed through culture. The figures may be on their own, their gaze often distant and melancholy, but they have to hand perhaps the best possible replacement when the immediate community has let us down: books.

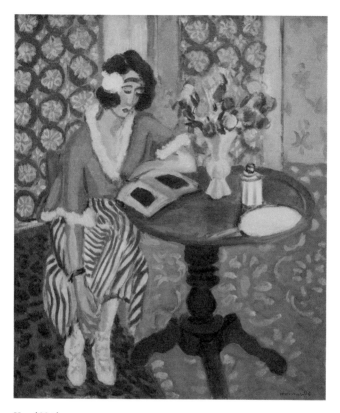

Henri Matisse,
Woman Reading at a Small Table,
c. 1923

The English psychoanalyst Donald Winnicott – working in the middle years of the twentieth century – was fascinated by how certain children cope with the absence of their parents. He identified the use of what he called 'transitional objects' to keep the memory of parental love strong even when the parents weren't there. So a teddy bear or a blanket, he realised, could be a mechanism for activating the memory of being cared for, a mechanism that is usefully mobile and portable and is always accessible when the parents are at bay.

Winnicott proposed that works of art can, for adults, function as more sophisticated versions of transitional objects. What we are at heart looking for in friendship is not necessarily someone we can touch and see in front of us, but a person who shares, and can help us develop, our sensibility and our values, someone to whom we can turn to and look for a sign that they too feel what we have felt, that they are attracted, amused and repulsed by similar things. Strangely, it appears that certain imaginary friends drawn from culture can end up feeling more real and in that sense more present to us than any of our real-life acquaintances, even if they have been dead a few centuries and lived on another continent. We can feel honoured to count them as among our best friends.

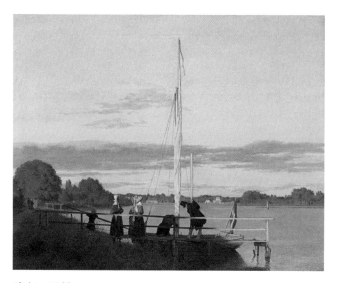

Christen Købke,
A View of Østerbro from Dosseringen,
1838

Christen Købke lived in and around Copenhagen in the
first half of the nineteenth century – he died of pneumonia
in his late thirties in 1848 – but we might consider him as
among our closest friends because of his sensitivity to just
the sort of everyday beauty that we may be deeply fond
of, but that gets very little mention in the social circles
around us. From a great distance, Købke acts like an ideal
companion who gently works his way into the quiet,
hidden parts of us and helps them grow in strength and
self-awareness.

The arts provide a miraculous mechanism whereby a stranger is able to do the things that we properly identify as lying at the core of friendship. And when we find these 'art-friends', we are unpicking the experience of loneliness. We're finding intimacy at a distance. The arts allow us to become the soulmates of people who – despite having been born in 1630 or 1808 – are in limited, but crucial, ways our proper companions. The friendship may even be deeper than that which we could have enjoyed in person, for it is spared all the normal compromises that attend social interactions. Our cultural friends can't converse fully of course and we can't reply (except in our imagination). And yet, they travel into the same psychological space, at least in some key respects, as we are in at our most vulnerable and intimate points. They may not know of our latest technology, they have no idea of our families or jobs, and yet, in areas that really matter to us, they understand us to a degree that is at once a little shocking and deeply thrilling.

Confronted by the many failings of our real life communities, culture gives us the option of assembling a tribe for ourselves, drawing its members from across the widest ranges of time and space, blending some living friends with some dead authors, architects, musicians

and composers, painters and poets.

The fifteenth-century Italian painter Verrocchio – one of whose apprentices was Leonardo da Vinci – was deeply attracted to the biblical story of Tobias and the Angel. It tells of a young man, Tobias, who has to go on a long and dangerous journey. But he has two companions: one a little dog, another an angel who comes to walk by his side, advise him, encourage him and guard him.

The old religious idea was that we are never fully alone; there are always special beings around whose aid we can call on. Verrocchio's picture is touching not because it shows a real solution we can in fact count on, but because it points to the kind of companionship we would love to have and yet normally don't feel we can find.

Yet, there is an available version. Not, of course, in the form of winged creatures with golden halos round their heads. But, rather, imaginary friends that we can call on from the arts. You might feel physically isolated in the car, hanging around at the airport, going into a difficult meeting, having supper alone yet again or going through a tricky phase in a relationship – but you are not psychologically alone; key figures from your imaginary

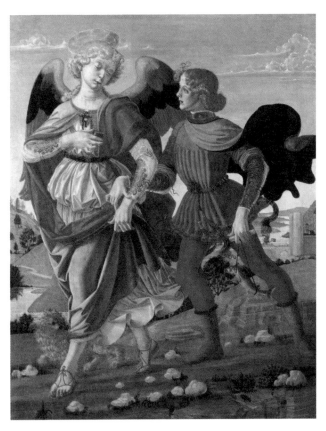

Andrea del Verrocchio,
Tobias and the Angel,
c. 1470–5

tribe (the modern version of angels and saints) are with you: their perspective, their habits of mind, their ways of looking at things are in your mind, just as if they were really by your side. And so we can confront the difficult stretches of existence not simply on the basis of our own small resources, but accompanied by the accumulated wisdom of the kindest, most intelligent voices of all ages gone by.

Given the enormous role of sadness in our lives, it is one of the greatest emotional skills to know how to arrange around us those cultural works that can best help to turn our panic or sense of persecution into consolation and nurture.

Hope

Much to the consternation of sophisticated people, a great deal of popular enthusiasm is directed at works of culture that are distinctly cheerful (songs about hope, films about couples that work through their problems); and in the visual arts, cheerful, pleasant scenes (meadows in spring, the shade of trees on hot summer days, pastoral landscapes, smiling children). The bestselling postcard of art in France turns out to be a reproduction of *Poppies* by Claude Monet.

Sophisticated people tend to scorn. They are afraid that such enthusiasms might be evidence of a failure to acknowledge or understand the awful dimensions of the world. But there is another way to interpret this taste: that it doesn't arise from an unfamiliarity with suffering, but from an all too close and pervasive involvement with it – from which we are impelled occasionally to seek relief if we are not to fall into despair and self-disgust. Far from naivety, it is precisely the background of suffering that lends an intensity and dignity to our engagement with hopeful cultural works.

In reality we rarely have the problem of being naively contented with our lives, or with the world in general. On the contrary, we are remorselessly confronted by our

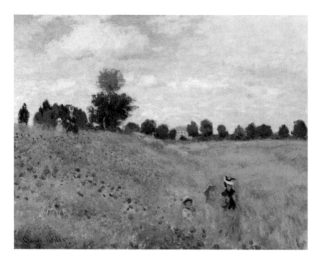

Claude Monet,
Poppies, 1873

own failings and by the radical imperfections of society. Rather than needing a stern dose of disenchantment, we're more likely to require art-tools that can feed and sustain our beleaguered optimism.

Renoir's idyllic picture of friends having a picnic together in the shade on a sunny day (*overleaf*) isn't imagining a fantasy world in which people magically never have troubles or sorrows. They may have boring jobs or tricky partners; they may have long hours of loneliness. It's just that, all the same, they can truly enjoy this opportunity

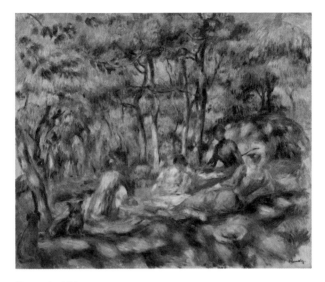

Hope made visible
Pierre-Auguste Renoir,
Picnic (Le Déjeuner sur l'herbe),
c. 1893

of pleasant friendship in a lovely place. Renoir isn't being sentimental. He's not implying that life as a whole is a picnic. He's portraying a much truer and more helpful idea of which we often need reminding: that despite the manifest failings of life and the world it is still possible for us to experience true pleasure. Which leads to the odd conclusion: if (by some strange chance) normal life were to become consistently delightful we would no longer need sweetly charming, hope-inducing works of art.

One of the less discussed powers of art is that, from time to time, it can bring tears to our eyes. It's normal to think that what makes people cry are sad things; that's certainly the way it works when you're a child. But the older we get, the more we start to notice an odd phenomenon: we start crying not when things are horrible (we toughen up a little), but when they are suddenly and unexpectedly precisely the opposite: when they are unusually sweet, tender, joyful, innocent or kind. This, far more than grimness, is what can increasingly prompt tears.

We can notice this in films. In Richard Linklater's *Before Midnight* (2013), most of the action comprises a bitter series of arguments between a 40-something couple, played by Julie Delpy and Ethan Hawke. They have been together for years, they are on holiday in Greece, and the film homes in on one day when the pair decide to spend time alone in a smart hotel. They arrive in their room with the possibility of sex somewhere in both of their minds but instead, find themselves having a blazing argument. They rake up all the hurt from past years; they blame each other for every disappointment, and swear at and insult one another with abandon. Eventually, the wife storms out, leaving her room key and her husband behind. It feels agonisingly real. But, after a few hours of sulking,

Hawke goes out in search of Delpy and finds her alone in a nearby restaurant terrace. They are both a little sheepish around each other, as one often is after a row, and he sits down opposite her with poignant formality. In a beautiful closing sequence, they start to talk with unusual honesty. It's difficult, but we can see that, despite everything (kids, too many sacrifices, exhaustion, not enough sex, perhaps a one-night stand or two), they do still love and desire one another very much. Their rage is an explosion of the frustration inherent within all long-term relationships. They get so deeply upset because they know that, day-to-day, they need so much from one another and they don't always get it. They're not magically going to stop bickering in the future, but this moment of kindness and sympathy, playfulness and gentleness, after such a bruising confrontation, comes as a huge relief and is deeply tender to behold. Their admission of shared love is moving because it reminds us at once of the struggles in our own lives and of what at heart we really want: reconciliation, forgiveness, tenderness, an end to the fighting, a chance to say sorry....

We start to cry at the brief vision of a state of grace from which we're exiled most of the time.

Bernard van Orley
(workshop of),
The Virgin and Child,
c. 1520–30

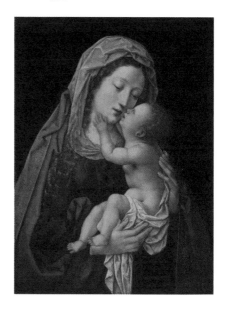

Something similar may happen around a much older
work, with a very different theme – such as this sixteenth-
century painting of the Virgin Mary with her child,
Jesus. Its emotional force is independent of its religious
meaning. We're seeing in her face, the face of true love
that we desperately wish might sometimes be turned on
us – filled with delight in our existence, warm, forgiving,
generous and sad for every trouble that will come our way.
When we look upon the picture with these thoughts in
mind, we glimpse the love we wish we could bestow on
others, but never quite manage to convey; and we see the

love we need but may never find. We would love someone to rest their head delicately upon ours, to close their eyes and think with every power of their imagination and understanding how deeply they long for our happiness, how readily they would stand in harm's way if only it were possible to save us from distress, how precious we are to them. And we cry because life is so seldom like this but so deeply should be. We are weeping at the loss of an idea, which means so much to us, and which we may catch sight of just for a moment when we look at a painting or read a passage in a children's story book, or catch the echoes of every lost love in the final notes of a song: the idea of true, redemptive love.

The more difficult our lives, the less it might take to make us cry; even a flower might start to move us. The tears – if they come – are in response not to how sad the flower is, but how its prettiness exists within such a very pitiless and mean world.

The more
difficult our
lives, the less
it might take
to make us cry;
even a flower
might start to
move us.

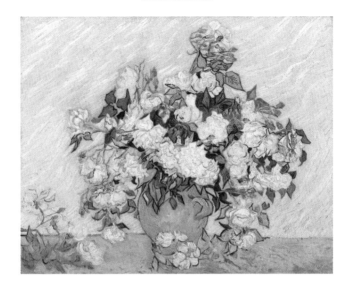

TOP
Vincent van Gogh,
*Still Life: Vase with Pink
Roses*, 1890

BOTTOM
Vincent van Gogh,
*Self-Portrait with Bandaged
Ear*, 1889

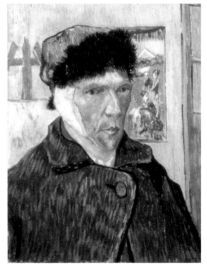

Across his life, Van Gogh produced exquisite paintings of flowers. Yet, self-evidently, he was overwhelmingly conscious of the darker sides of the human condition. His deep love of flowers wasn't a denial of life's grimness – or a naive failure even to acknowledge it. It was his radical recognition of sorrow that made him extremely sensitive to, and appreciative of, the transient grace of delicately tinted roses in bloom.

There's a strange contrast we sometimes catch sight of around parents and children. The child might be joyfully singing and dancing along to a favourite song. As they watch, the parent's delight has a different quality: they are deeply conscious of how fragile and fleeting such moments of intense happiness are; they see this lovely, innocent moment against the backdrop of life's sorrows and troubles – adding a layer of poignancy and tenderness which the child can't as yet imagine. And this is what makes the sight so moving to the parent.

It's not fair to condemn all art that is joyful or sweet as 'sentimental' and therefore unworthy of the attention of an intelligent adult who has a realistic view of existence. The pleasure we take in pretty, charming or very gracious art doesn't at all mean we are naively

denying the darker aspects of the world or of our own nature. We're not pretending that the pretty work is an accurate portrait of existence – in fact, we're agonisingly conscious that it isn't. It's because we're burdened with frustrations, disappointments, failings, errors, regrets and compromises that the sight of grace, innocence, lightness and carefree joy is so moving; and if we cry it is because we're glimpsing something we love and need and yet cannot now hold on to.

For many of us, instead of being complacent and unwilling to confront awkward truths, we're liable to have the reverse problem: we're so aware of what's wrong that we're despondent and paralysed. The Beatles' warm, supportive song 'Hey Jude' (1968), with its key line, 'don't be afraid', sees the reasons for potential despair as obvious: we get withdrawn and lonely, we give up, our problems feel too big. The song's optimism isn't denying this. Instead, it sees hope and cheerfulness as important ingredients in facing difficult situations. Similarly, one of Mozart's most beautiful arias – 'Sleep Softly' from *Zaide* (1780) – captures a beautiful moment of love: you see your partner sleeping and you feel incredibly tender towards them. It's not a denial that couples often squabble, disappoint and frustrate one another. It's not

pretending that this is how we always feel. Rather it's taking a rare, and very lovely, experience and preserving it, so that we can strategically reconnect with it when things have grown dark. It is because we are so aware of how hard relationships can be that we need an artificial way of reminding ourselves of the very positive and kindly feelings we also really do have towards our partners – but which tend to get lost amongst the normal conflicts and stand-offs of being together.

We're leaky creatures. Hope drains away, not because the situation is genuinely hopeless but because we are so attuned to seeing what's wrong. It's precisely because we so readily lose hope that the optimistic reminders provided by culture – hope in amber – are so important to us.

Balance

Few of us are entirely well 'balanced'. Our psychological histories, relationships and working routines mean that many of our emotions incline a little too much in one direction or another. We may, for example, have a tendency to be too complacent. Or else too insecure or too trusting. Or too suspicious, too serious. Or too lighthearted, too calm or too excited.

The particular imbalances we suffer from may be specific to us, but the phenomenon of being unbalanced is general – and, surprisingly, it is an issue that culture is particularly placed to help us with, for works can put us powerfully in touch with concentrated doses of our missing dispositions, and thereby restore a measure of equilibrium to our listing inner selves.

It is an emotional skill to be ready to sense an inner imbalance and then to take the steps necessary to rectify it with the help of culture. We might register that we are suffering from a mood of longing and disenchantment with what strike us as our rather humdrum and ordinary lives. The realisation isn't complex in itself; what counts is the confidence to see that culture might have a solution to our mood – as well as the imagination to seek it out. We might find our way to a film about an ordinary

schoolteacher who we, the audience, realise is delightful even though they lack any of the external markers of status. Through the film, we may be taught how to see the very real dignity and grace of ordinary life, and recognise that a little of this, fairly, belongs to us as well.

In another mood, we may discern that it is a different sort of film we need. We often go so far down the track of teaching ourselves about the importance of gentleness and compromise, that sometimes we unwittingly develop a problem with self-assertion and resistance to the demands of others. We might have learned too well to suppress our own appetite for a fight, our own desire for victory. In a world where conflict is unavoidable, good people sometimes need to strengthen their willingness to face down opposition – not always to compromise and play it safe, but to take risks instead, to get out and fight, to relish victory and to be a bit more ruthless in the service of noble and deeply important ends. Sometimes it is not enough to be right: you also need to win.

So, some of us might well benefit from watching films that tell tales of heroism: that follow someone who has to navigate the world, kill a dragon, outwit some baddies, or penetrate a corrupt organisation. Ideally, the film

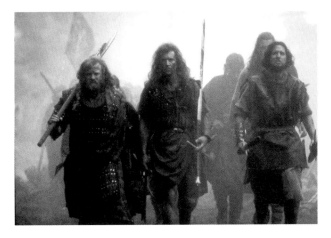

Mel Gibson,
Braveheart, 1995

shouldn't simply leave us in awe at the daring of another. It should do that far more valuable thing: educate us by example, so that we too become just a little more heroic and brave where we need to be.

The notion that art plays a crucial role in rebalancing us emotionally can answer the vexed question of why people differ so much in their aesthetic tastes. Why are some people drawn to minimalist architecture and others to the baroque? Why are some people excited by bare concrete walls and others by floral patterns? Why do some like quiet films about relationships and others

war epics? Our tastes will depend on what spectrum of our emotional makeup lies in shadow and is hence in need of stimulation and emphasis. Every work of art is imbued with a particular psychological and moral atmosphere – serene or restless, courageous or careful, modest or confident, masculine or feminine, bourgeois or aristocratic – and our preferences for one kind over another reflects our varied psychological gaps. We hunger for artworks that will compensate for our inner fragilities and help to return us to a viable mean.

Life might be a frantic whirl of demands, deadlines, appointments and meetings; by the end of every day we're worn out and on edge; we've been on constant high alert for what feels like forever; there's scarcely a moment to think, to define our own priorities or to take stock of where we are in our lives. It wouldn't be at all surprising if, in such a state, we looked with longing at a serene, emphatically quiet interior as the much-needed ideal home to which we need to find our way for a period of respite.

Of course, the character of our individual lives varies enormously. So the balancing agents that instinctively appeal to us will be equally diverse. We might have a life

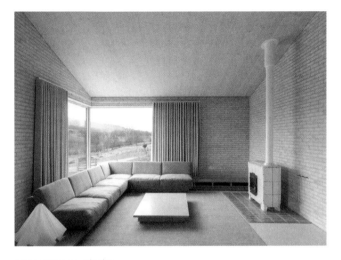

Art to counter our agitation
John Pawson: The Life House, Wales,
2011–16

too heavily impressed by routine: the tasks of one day are essentially the same as all the rest; we can predict from week to week what time we'll get home; perhaps a relationship has settled into an over-familiar groove; without maybe fully acknowledging it to ourselves we feel that life has become a bit stale. In that case, we're not at all likely to feel the allure of Pawson's deeply calm and minimalist architecture. Instead we will perhaps feel strangely but powerfully attracted to the drama of a facade by the Roman Baroque architect Francesco Borromini – a work with the power to rouse our slumbering souls.

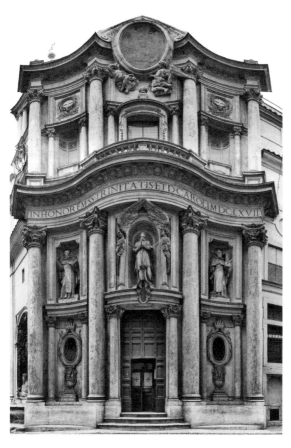

Art to rouse our sluggish passions
Francesco Borromini: San Carlo alle Quattro Fontane, Rome, 1638–41

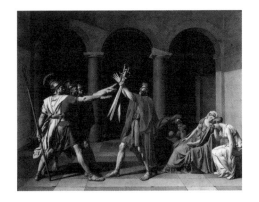

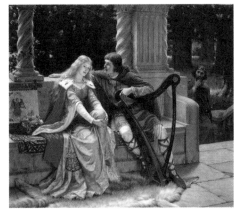

TOP

Art to rebalance oneself
after too many mistresses,
too much gold and too
many decadent parties
Jacques-Louis David,
The Oath of the Horatii,
1784

BOTTOM

Art to rebalance oneself
after too many railways,
factories and readings of
Darwin
Edmund Leighton,
The End of the Song,
1902

Whole nations can manifest longings for balance and will use art to help them achieve it. After too much aristocratic decadence, many in late-eighteenth-century France felt the need to get back in touch with martial solemnity and spartan simplicity and so found refuge in the pared-down works of Jacques-Louis David.

By the later part of the nineteenth century in England, the materialism, scientific obsession and capitalist rationality of the age drove many to long for more faithful, mystical days, and so to locate 'beauty' in images such as Edmund Leighton's *The End of the Song* (1902), inspired by the literature and history of the Middle Ages.

What we call 'beautiful' is any work of art that supplies a missing dose of a much-needed psychological component, while what we dismiss as 'ugly' is that which forces on us moods or motifs that we feel threatened or already overwhelmed by. Our contact with art holds out the promise of inner wholeness

Compassion

One of the things that makes us fear failure the most is the way we imagine we'd be seen by others. We'd not merely fail, we'd be called losers, burdened by the additional – and in some ways more ghastly – prospect of being figures of ridicule and contempt in the eyes of most people.

Our fear isn't unfounded. Generally, failure and personal disaster are treated very severely in social life. We can imagine how a mean-spirited group of people after work or at a party would make fun of the world's most august failures – the central characters of tragic novels and plays: Oedipus, Hamlet, Raskolnikov or Jay Gatsby. The media would be even crueller, coming up with lurid summations like a classic headline version of the ancient Greek story: SEX WITH MUM WAS BLINDING. They might state the fate of Hamlet as: BOOZY FOREIGN ARISTO DIES IN FIGHT AFTER KILLING SPREE; *Crime and Punishment* would be: CALL-GIRL MAKES PSYCHO KILLER CONFESS and *The Great Gatsby* would be reduced to: FAKE GENT SHOT IN DELUX POOL BY WRONG LOVE-RIVAL.

These headlines come across as cheap and mean only because the stories behind them have been so powerfully elaborated by novelists and dramatists. Without Sophocles, Shakespeare, Dostoyevsky or Scott Fitzgerald,

we'd never think of the complex, moving personal histories of individuals that lie behind these harsh summaries. Figures like these strike us as fascinating and worthy of sympathy only because we've been taught by the best teachers to see them through the prism of artistic sympathy and compassion.

The idea of rescuing failure from unjust contempt lies behind one of the world's oldest and most impressive theories of art. The idea of Tragedy was developed by the ancient Greek philosopher Aristotle in his *Poetics* (384–22 BC). In the book, Aristotle wasn't at all pretending that individual responsibility doesn't matter. His goal was to show that even perfectly decent people can end up in horrific situations and that therefore they deserve to be regarded with tender pity rather than disgust. It's not that it isn't in some way their fault. These people are not merely unlucky. But the thing in their nature that leads to their downfall isn't in itself all that different from our own failings. To capture this crucial point, Aristotle defined their failings as *harmatia* or 'flaws' – someone is a bit impetuous, they sometimes lose their temper; they let ambition get in the way of caution; they don't properly listen to what another person is saying. These are imperfections, but they are very common. And

sometimes these flaws have terrible consequences. We might lose our temper at the worst possible moment and shout at someone who turns out to have the power to wreck our lives; a hasty decision might lead to financial ruin; or we might brush aside someone who is trying to tell us something that turns out to be really important. These are the staple moves of Greek Tragedy as analysed by Aristotle. And his point is this: those who end up in horrendous trouble haven't necessarily got any deeper flaws in their characters than we do in our own.

It's the polar opposite of an attitude that suggests that failure is always the sign of something being very wrong with someone (the attitude implied by media headlines). These headlines hint that their victims, caught up in grotesque events, are not at all like us; we don't have to feel for them because they belong almost to a different species. It could never happen to us. The whole thrust of Aristotle's *Poetics* is that tragedy is a vehicle of education. It teaches us to feel pity, rather than contempt, for those whose lives turn out very badly.

To drive this point home Aristotle makes a particular recommendation to people writing plays: make sure, he says, that the person to whom the bad things happen

is 'like us, or only slightly better than us.' When we first meet the character, says Aristotle, they have to be likeable, even a touch impressive. We have to be invited to warmly identify with them or admire them. And then, he continues, their disasters have to unfold in a short span of time, so that our original liking for this person is still fresh in our minds. In life we often have weeks or months in which to forget that someone to whom disaster comes is really rather nice. We have time to detach emotionally from them before we start to see them simply as losers. By speeding up the process Aristotle's hope is that we don't have time to forget; we can see that these awful things are happening to someone as nice as or slightly nicer than us and only for faults that are similar to or no worse than our own.

An attitude of mockery and contempt is driven by the background thesis that the 'loser' is fundamentally unlike us. This is what gives our severe attitudes free rein. We simply refuse to imagine that this kind of misfortune might come our way. We'd never end up there, we imagine. We'd never be on the receiving end of fate, so we have no motive to moderate our condemnations. We're prone to mocking a politician who freezes in an interview; a married father of three children who gets caught with

his mistress; someone who puts their life savings into a business venture that doesn't work out.... And the reason is that we don't have in mind the small steps which could take a perfectly ordinary person to these places. And this is where Aristotle comes up with a crucial idea. In a great tragic story it is necessary to make the plot 'probable' – that is, we need to feel that what went wrong for this person happened little by little; they couldn't see at the time that it was all heading for disaster. Gradually, they got in deeper. Being able to imagine this kind of story is crucial to sympathy because it is the account of how we too might, without quite realising it, get caught up in a dreadful situation. We're often tempted to say 'I can't imagine how a sensible person could have done that.' Aristotle is proposing art as a way of making us more accurately imaginative.

In January 1872, a thirty-five-year-old woman called Anna Pirogova committed suicide by throwing herself under a train at the recently opened railway station at Yasenki, a modest provincial town about 200 kilometres south of Moscow. It turned out she was the housekeeper of a local landowner whose wife had died some time before; they'd been having an affair and she'd been expecting to marry him. But he'd just told her that he was instead planning to

marry the more alluring German governess who looked after his son. The inquest would have been a routine affair had it not been for the presence of Russia's most distinguished novelist, Leo Tolstoy, who had recently achieved huge success with the publication of *War and Peace*. It was his local station, his family estate lay just beyond the town, and his wife was in fact distantly related to Anna Pirogova. The event made a deep impression on Tolstoy. It was obvious to him that many people would have limited sympathy for this woman. He could imagine how her suicide would be chatted about in the social circles of Moscow and St Petersburg. She'd already lost all right to pity when she had an affair; she had been angling to catch her boss; she was ditched for a more attractive rival – what did she expect? She was stupid, unprincipled and hysterical; it was all her own fault. The tabloid headline might read: STATION SUICIDE OF SOCIAL CLIMBING ADULTERESS.

Tolstoy's reaction was entirely different. He used the grim death of Anna Pirogova as a model for the climax of his next great novel, *Anna Karenina*, of which the first instalment was published the following year. At the end of the long novel, the heroine (also called Anna) commits suicide by throwing herself under a train, after being

rejected by the man with whom she was having an illicit affair. But this only happens in the closing pages. Much of the rest of the long novel can be seen as an attempt to understand, as sympathetically as possible, how someone could end up doing this. In his novel, he ups the stakes. The Anna of the book is, when we first meet her, a deeply engaging person: she has a warm, generous nature, she's elegant and charming, she's cultivated and clever, and she's married, with a child, to a leading official in the government.

Tolstoy then traces the unfortunate factors, the slight mistakes, the little steps that gradually bring this obviously lovely person to a horrific end. Anna Karenina has an awkward marriage, but it's not her fault. She was married off at a young age by her family; and she's tried very hard to be loyal to her husband. Quite by chance she meets a deeply fascinating man; she dances with him at a ball and then decides never to see him again. But he happens to be immensely persistent. He trails after her around the country, he gets himself invited to parties that she has to attend with her husband. Eventually, slowly, he seduces her. It's not a meaningless fling, he's genuinely in love with her, totally sincere, talented and sophisticated. Anna pleads for a divorce. But her husband rejects the idea

for purely tactical reasons; he doesn't care about Anna personally but it would be inconvenient to go through divorce proceedings when he's so busy with work.

Eventually Anna elopes with her lover – but the price is that she can never again see her son. Her husband coldly refuses access, and this breaks her heart. They have to live in the country, because they would be rejected in the city; her lover has to give up his career, he grows restless. Increasingly desperate, Anna turns to drugs to calm herself. Her lover becomes more and more frustrated and brusque, frequently spending time away from Anna. They row constantly and Anna becomes convinced that he no longer loves her. She has destroyed everything she had for him and now she feels that it's been all for nothing. She takes a carriage to the station and throws herself under the wheels of an oncoming train.

Anna Karenina's story is not precisely the same as that of Anna Pirogova – the housekeeper whose suicide was an inspiration for the novel. Yet the difference between the novel and the gossip lies primarily in the way the story is told. Tolstoy's narrative is an unflinching but deeply generous account of how a life can be utterly ruined and how a person who is (at the start) immensely charming,

The difference
between
the novel and
the gossip
lies primarily
in the way the
story is told.

kind and intelligent can end up, by their own action, a mangled corpse on a railway track. It is, in essence, the story as seen through the eyes of love, the opposite of the critical, dismissive, cold voice of gossip.

The point of being repeatedly exposed to this loving, understanding voice is that ultimately, it becomes the voice in which we can start to tell our own story. We too are inept, flawed, messy creatures heading – at some point – for a fall. So it matters immensely that lodged in our minds we have a voice that isn't just the punitive one of the public square, but one that can make some of the same moves as we witness in Sophocles, Shakespeare or Flaubert. It isn't a case of writing up our lives as they would have done. It's seeing that, in our failures, we deserve no less sympathy than the unfortunate victims of the world's greatest tragedies. A world in which people properly imbibed the lessons implicit within tragic art would be one in which the consequences of failure would cease to weigh upon us so heavily, a world in which we had learnt how to extend a loving perspective upon ourselves, and on our fellow wretched humans.

Knowledge

One of the more frustrating, yet fundamental, things about being human is that we can't understand ourselves very well. Either side of the mind frequently has no clear picture of what the other happens to be upset about, anxious of or looking forward to. We make a lot of mistakes due to a pervasive self-ignorance.

Here too culture can help, because in many cases, it knows us better than we know ourselves and can provide us with an account (more accurate than any we might be capable of) of what is likely to be going on in our minds.

Marcel Proust's lengthy 1913 novel, *In Search of Lost Time*, is seemingly the story of a collection of aristocratic and high bourgeois characters living in early twentieth-century France. However, towards the end of the book, the writer makes a remarkable claim. His novel wasn't really about these distinctly remote-sounding people, it was about someone closer to home, you:

> In reality, every reader is, while he is reading, the reader
> of his own self. The writer's work is merely a kind of
> optical instrument which he offers to the reader to
> enable him to discern what, without this book, he would
> perhaps never have experienced in himself. And the

recognition by the reader in his own self of what the book says is the proof of its veracity.

In the great works of culture, we have an impression of coming across orphaned pieces of ourselves, evoked with rare crispness and tenacity. We might wonder how on earth the author could have known certain deeply personal things about us, ideas that normally fracture in our clumsy fingers, but that are here perfectly preserved and illuminated. Take, for example, the self-knowledge offered by one of Proust's favourite writers, François VI, Duc de La Rochefoucauld, author of a slim volume of aphorisms known as the *Maxims* (1665–78):

> We all have strength enough to bear the misfortunes of others.

It's an idea closely followed by the equally penetrating:

> There are some people who would never have fallen in love, if they had not heard there was such a thing.

And the no less accomplished:

> To say that one never flirts is in itself a form of flirtation.

We are likely to smile in immediate recognition. We have been here ourselves. We just never knew how to condense our mental mulch into something this elegant.

When Proust compares literature to 'a kind of optical instrument', what he means is that it performs the function of a high-tech machine, helping us to focus on what is really unfolding within ourselves and within others around us. Great authors turn vagueness into clarity. For example, if we have read Proust, and are then later abandoned by a lover who very kindly professes their need to spend 'a little more time on their own', we will benefit from having seen the dynamic clearly captured in Proust's line from his 1923 work *The Prisoner*: 'When two people part, it is the one who is not in love who makes the tender speeches.' The clarity won't make the lover return; but it will do the next best thing: help us to feel less confused by, and alone with, the misery of having been left.

The more writers we read, the better our understanding of our own mind stands to be. Every great writer can be hailed as an explorer – no less extraordinary than Magellan or Cook – of new, hitherto mysterious corners of the self. Some explorers discover continents, others spend

The more writers we read, the better our understanding of our own mind stands to be.

their lives perfectly mapping one or two small islands, or just a single river valley or cove. All deserve to be feted for correcting the ignorance in which we otherwise meander through our internal world. The Japanese poet Matsuo Basho clarifies our feelings of loneliness, Tolstoy explains our ambition to us, Kafka makes us conscious of our dread of authority, Camus guides us to our alienated and numb selves, and under Philip Roth's guidance we become conscious of what happens to our sexuality in the shadow of mortality.

The twentieth-century English writer Virginia Woolf did not enjoy good health. In an essay titled 'On Being Ill' (1930), she lamented how little we tend to clearly grasp what illness really feels like. We casually say we're not well, or have a headache, but we lack a focused vocabulary for our ailments. There is one large reason for this: because of how little illness has been written about by talented authors. As Woolf remarks:

> English, which can express the thoughts of Hamlet
> and the tragedy of Lear, has no words for the shiver
> and the headache. It has all grown one way. The merest
> schoolgirl, when she falls in love, has Shakespeare or
> Keats to speak her mind for her; but let a sufferer try to

describe a pain in his head to a doctor and language at once runs dry. There is nothing ready made for him.

This turned out to be one of Woolf's great tasks as a literary explorer. She brought into focus what it's like to be tired, close to tears, too weak to open a drawer, irritated by a pressure in one's ears or beset by strange tremors in one's chest. Woolf became the Columbus of illness.

One effect of reading a book that has devoted attention to noticing such faint yet vital tremors, is that once we've put the volume down and resumed our own lives, we find ourselves responding to precisely the things that the author would have noted, had he or she been in our place. With our new optical instrument, we're ready to pick up and see clearly all kinds of new objects floating through our consciousness. Our attention might be drawn to the shades of the sky, to the changeability of a face, to the hypocrisy of a friend, or to a submerged sadness about a situation that we had previously not even known we could feel sad about. A book will have sensitised us, stimulated our dormant antennae by evidence of its own developed sensitivity. Which is why Proust proposed, in words he would modestly never have extended to his own novel, that:

> If we read the new masterpiece of a man of genius, we are delighted to find in it those reflections of ours that we despised, joys and sorrows which we had repressed, a whole world of feeling we had scorned, and whose value the book in which we discover them suddenly teaches us.

These lines connect up with an equally prescient quote from Ralph Waldo Emerson's 1888 essay 'Self Reliance':

> In every work of genius we recognize our own rejected thoughts.

It isn't just ourselves we learn about through culture. It is also, of course, the minds of strangers, especially those we would not ordinarily have ever learnt much about. With our optical instruments in hand, we are able to learn about family life in Trinidad, about being a teenager in Iran, about school in Syria, love in Moldova and guilt in Korea. We get taken past the guards right into the King's bedroom (we hear him whispering to his mistress or doubting his attendants) and the pauper's hovel, the upper middle-class family's holiday villa and the lower middle-class family's caravan.

Thanks to all this, we have a rare opportunity to spare

ourselves time and error. Literature speeds up the years: it can take us through a whole life in an afternoon, and so lets us study the long-term consequences of decisions that, in our own cases, would work themselves out dangerously slowly. We have a chance to see in accelerated form what can happen when you worry only about art and not so much about money, or only about ambition and not so much about your own children; what happens when you despise ordinary people or are disturbingly concerned with what others think. Literature helps us avert mistakes. All those heroes who commit suicide, those unfortunate demented souls who murder their way out of trouble and those victims who die of loneliness in unfurnished rooms are able to teach us things. Literature is the very best reality simulator we have – a machine that, like its flight equivalent, allows us to safely experience the most appalling scenarios that would, in reality, take many years and great danger to go through, in the hope that we'll be ever so slightly less inclined to misunderstand ourselves, swerve blindly into danger or succumb before time.

Encouragement

In England in the 1880s, a group of art lovers – most of them young, forward-looking and metropolitan – began a movement known as aestheticism. Their core belief was that in a rapidly secularising world, culture could provide us with a new moral framework; it could, as religion had once done, guide, inspire and console us. In particular, it could play a vital role in encouraging us to be good, because beautiful objects and environments were not, in the eyes of aestheticists, merely meaninglessly pretty. They were goads to virtue. The aestheticists believed – as the Ancient Greeks had done before them – that beauty was synonymous with goodness, while ugliness was an incarnation of corruption.

This analysis transformed badly designed objects and environments from unfortunate eyesores to political priorities; after all, they weren't just ugly, they might make us bad. Cities, houses, chairs, plates and teapots needed to be attractively made, in order to generate the right sort of atmosphere around which good lives could unfold.

The aestheticists were easy to mock. Many of them had somewhat earnest and precious airs. The satirical magazine *Punch* took regular aim at them. In one cartoon, an ardent young couple examine a teapot they have

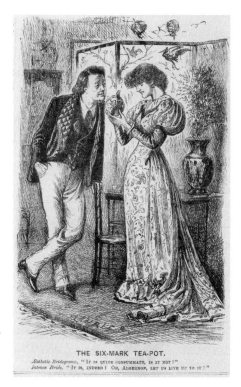

THE SIX-MARK TEA-POT.

Æsthetic Bridegroom. "IT IS QUITE CONSUMMATE, IS IT NOT!"
Intense Bride. "IT IS, INDEED! OH, ALGERNON, LET US LIVE UP TO IT!"

George Du Maurier,
'The Six-Mark
Tea-pot',
Punch, 1880

received as a wedding gift: 'It is quite consummate, is it not!' exclaims the bridegroom. 'It is indeed!' replies his bride, 'Oh Algernon, let us live up to it!'

The idea of 'living up to' a teapot sounds daft, but it contains a not-at-all inane background thesis: that the quality of designed environments matters because we

are hugely vulnerable to the suggestions emanating from them about how we might behave, and more broadly, who we might be. In degraded, battered, run-down streets (and in a lesser way, around ugly tea-pots), it is easier for hope to escape and for the worst sides of our nature to come to the fore, whereas on dignified thoroughfares (and around well-made tea pots), our better aspects are seductively invited to flourish.

This degree of aesthetic ambition would not have sounded in any way strange to the Zen Buddhist philosophers behind the Japanese tea ceremony. These theorists paid acute attention to the design of the teacups and teapots, because they felt that they could operate as powerful visual reminders of prized Zen tenets about modesty and forbearance. Minor blemishes were deliberately allowed to remain on cups so as to remind drinkers that imperfection is an inevitability to which we should graciously accommodate ourselves. The glaze was unevenly applied and the overall shape often a little wonky, so as to nudge us towards a serene acceptance of our own flaws. The cups were conceived of as small lessons of wisdom embodied in ceramic.

If a teacup can have the power to affect character, then so

Philosophy in a teacup

too must the most imposing of all the arts: architecture. In 1961, the government of what was then East Pakistan and is now Bangladesh started the construction of a new parliament building in the capital city, Dhaka. The country was deeply beset by economic problems and by intense ethnic rivalries; its administrative system tended to corruption; it was horrifically exposed to catastrophic cyclones and floods. But rather than try to reflect the actual country, it was decided to commission a building – by the great American architect Louis Kahn – that could present a vision of the country as it might and could be in the future.

Kahn's complex of buildings in Dhaka (*overleaf*) are emphatically solid and enduring; they can bear the assaults of storms and floods; the logical, geometrical

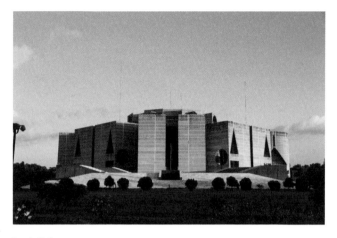

Louis Kahn,
National Assembly Building,
Dhaka, 1970

forms speak of a world in which civil servants and
administrators make coolly rational judgements in the
national interest, without reference to personal benefit;
in the light-filled chambers and lobbies there will be
careful, serious discussion of long-term solutions; the
parliamentarians and civil servants will become like the
building and, via them, so too will the nation.

The building is intended as a kind of seduction. Generally
we think of seduction only in its worst versions. But there
is a good version in which we are gently but persuasively

enticed to let go of our normal habits and develop in a hopeful direction. Seduction works not by sternly telling us to do something but by subtly conveying how nice it might be if we did so. It lures our senses and our imaginations; it foregrounds certain moods (un-panicked, sincere, quietly dignified) and gives us greater confidence in them; it implies that they are, or should be, normal. In the company of the right building (as in the company of the right friend) we find it easier to become the better versions of who we really are.

The Parliament building in Dhaka, like many a beautiful city, street, chair or teapot, matters because of its skill at encouraging the better sides of us. This is no idle or dispensable project. We are always on the verge of forgetting the lessons in goodness and fulfilment we know in theory – and lie at the mercy of messages whispered by our environment. We need to build lives in which we can arrange around us the kind of art that will daily bring the best sides of us to the fore.

Appreciation

At the centre of our societies is a hugely inventive force dedicated to nudging us towards a heightened appreciation of certain aspects of the world. With enormous skill, it throws into relief the very best sides of particular places and objects. It uses wordsmiths and image makers of near genius, who create deeply inspiring and beguiling associations – and it positions works close to our eyelines at most moments of the day. Advertising is the most compelling agent of mass appreciation the world has ever known.

Because advertising is so ubiquitous, it can be easy to forget that – of course – only a very few sorts of things ever get advertised. Almost nothing is in a position to afford the budgets required by an average campaign, something overwhelmingly reserved for those wealthy potentates of modern life: nappies, cereal bars and hand sanitisers. This has a habit of skewing our priorities. One of our major flaws as animals, and a big contributor to our unhappiness, is that we are very bad at keeping in mind the real ingredients of fulfilment. We lose sight of the value of almost everything that is readily to hand, we're deeply ungrateful towards anything that is free or doesn't cost very much, we trust in the value of objects more than ideas or feelings, we are sluggish in

David Hockney,
Three Trees near Thixendale, Summer,
2007

remembering to love and to care, and are prone to racing through the years while forgetting the wonder, fragility and beauty of existence. It's fortunate, therefore, that we have art.

One way to conceive of what artists do is to think that they are, in their own way, running advertising campaigns; not for anything expensive or usually even available for purchase, but for the many things that are at once of huge human importance and yet constantly in danger of being forgotten. In the early part of the twenty-first century, for example, the English artist David Hockney ran a major advertising campaign for trees.

TOP Albrecht Dürer,
Great Piece of Turf, 1503

RIGHT Pierre Bonnard
Woman with Dog, 1922

BOTTOM Mary Cassatt
Mother Playing with her Child,
1899

At the start of the sixteenth century, the German painter Albrecht Dürer launched a comparable campaign around the value of grass (*top left*). In the psychological field, the French painter Pierre Bonnard carried out an exceptionally successful campaign for tenderness, turning out dozens of images of his partner, Marthe, viewed through lenses of sympathy, concern and understanding (*top right*). In an associated move, the American painter Mary Cassatt made a good case for the world-beating importance of spending some time with a child (*bottom*).

These were all acts of justice, not condescension. They were much needed correctives to the way in which what we call 'glamour' is so often located in unhelpful places: in what is rare, remote, costly or youthful. If advertising images carry a lot of the blame for instilling a sickness in our souls, the images of artists reconcile us with our realities and reawaken us to the genuine, but too-easily forgotten, value of our lives.

Consider for instance Vanessa Bell's quiet picture of her daughter sitting in an arm chair, concentrating on the book she's reading (*overleaf*). It's a seductive scene – but the charm Vanessa Bell is interested in isn't expensive or remote. The room might have a few more books in it than

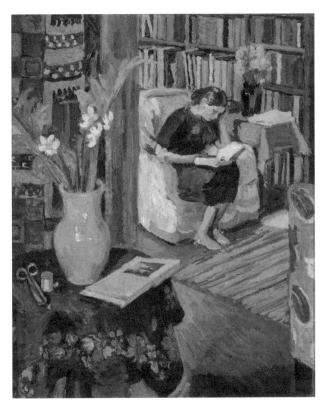

Vanessa Bell,
Interior with the Artist's Daughter,
c. 1935–36

our own, but the details, which are lovingly picked out, are modest: a simple rug, a plain vase, a few flowers. And the centre of the allure is the daughter's intent attitude, with her feet slightly tucked together. It's not fake glamour: it's a genuine highlighting of something lovely that we can directly pursue at little cost, if we want, in our own lives.

Art doesn't have to tantalise us with alluring visions of things we can never attain. It's capable of drawing our admiration to the easily forgotten, but very real, charms and dignity of everyday life. And it can – in this way – usefully reconcile us to the unavoidable imperfections of existence – a job that's not all it could be (but does have some genuinely nice moments); a relationship that's certainly not ideal – but does contain much that is, in less dramatic ways, quite pleasing; things which we could value more justly, perhaps, if more often, works of art shone their spotlight of loving admiration upon them.

Art can do the opposite of glamorising the unattainable; it can reawaken us to the genuine merit of life as we're forced to lead it. It is advertising for the things we really need.

Perspective

Because of the way our minds work, it is very hard for us to be anything other than immensely preoccupied with what is immediately close to us in time and space. But in the process, we tend to exaggerate the importance of certain frustrations that do not, in the grander scheme, merit quite so much agitation and despair. We are inveterately poor at retaining perspective. Here, too, culture can help – by carrying us out of present circumstances and reframing events against a more imposing or vast backdrop.

Some extremely worrying-sounding things are, always, happening in the world. We are surrounded by a media industry that knows it must scare us to survive and that the one thing (despite its overt commitment to free speech) it must always censor is the idea that things might, on balance, be OK. One place we can turn to for relief is in a resource that powerfully reminds us that extreme difficulties are never new, that the worst sounding troubles can be survived and that it has (extraordinarily) often been a lot worse even than this. That antidote goes by the name of history.

When political events seem to have reached a new low, we might – for example – turn to the writings of the ancient

Roman historian Suetonius. Born towards the end of the first century AD, Gaius Suetonius Tranquillus was an imperial administrator, chief secretary to the Emperor Hadrian and the first historian to attempt an accurate biographical portrayal of the rulers of the Roman Empire, from Julius Caesar down to Domitian. It's a shocking story. Suetonius's book, *The Lives of the Twelve Caesars* (121 AD), amounts to a catalogue of extraordinary follies and crimes of the first twelve men to rule the western world. Amongst them, we find:

JULIUS CAESAR: A thief, a liar, an egomaniac and a murderer.

CALIGULA: A notorious psychopath who, to quote Suetonius, 'condemned [people] to the mines, to work at building roads, or to be thrown to the wild beasts; or else he shut them up in cages on all fours, like animals, or had them sawn asunder. Not all these punishments were for serious offences, but merely for criticising one of his shows, or for never having sworn by his Genius.' We also hear that the method of execution he preferred was to inflict numerous small wounds, but to avoid all major organs, and that he often gave the command: 'Strike so that he may feel that he is dying.'

NERO: Of him we hear that he: 'devised a kind of game, in which, covered with the skin of some wild animal, he was let loose from a cage and attacked the private parts of men and women, who were bound to stakes', and that he wandered through the streets at night randomly murdering strangers and throwing their bodies into the sewers.

VITELLUS: His ruling vices were gluttony and cruelty. He banqueted three or four times a day and he survived by taking frequent emetics. He used to give himself a treat by having prisoners executed before his eyes.

DOMITIAN: 'At the beginning of his reign he used to spend hours in seclusion every day, doing nothing but catching flies and stabbing them with a keenly-sharpened stylus'.

Though Suetonius writes about grotesque people – who were also at the time the most powerful people on the planet – he can leave us feeling remarkably serene. We might read him tucked up in bed, after news of the latest catastrophe. The experience is strangely reassuring, because at heart, it is a narrative of resilience.

Suetonius writes of earthquakes, plagues, wars, riots,

rebellions, conspiracies, betrayals, coups, terrorism and mass slaughter. Considered on its own it might seem to be the record of a society whose collapse must surely be imminent. But, in fact, Suetonius was writing before – and not after – one of the most impressive periods of Roman achievement, which would come fifty years later under the rule of the stoic philosopher and emperor Marcus Aurelius.

The disasters that Suetonius catalogues were compatible with a society heading overall towards peace and prosperity. Reading Suetonius suggests that it is not fatal for societies to be in trouble; it is, in fact, usual for things to go rather badly. In this respect, reading ancient history generates the opposite emotions to scanning today's news. Events have been much worse before and things were, in the end, OK. People behaving very badly is a normal state of affairs, and there have always been existential threats to the human race and civilisation. It makes no sense, and is a form of twisted narcissism, to imagine that our era has any kind of monopoly on idiocy and disaster. By reading Suetonius we enter unconsciously into his less agitated and more stoic reactions. He, and history more generally, encourage connection to what we need now more than ever: the less panicky, more resilient side of ourselves.

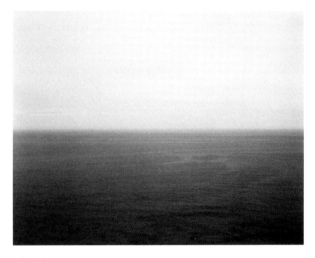

Hiroshi Sugimoto,
Atlantic Ocean, Martha's Vineyard,
1986

In a very different medium, a similar move is being made by the Japanese photographer Hiroshi Sugimoto through his gigantic empty photographs of seas and oceans in a variety of moods. What is most notable in these sublime scenes is that humanity is nowhere in the frame. We are afforded a glimpse of what the planet looked like before the first creatures emerged from the seas. Viewed against such an immemorial backdrop, the precise discontents in our relationship, the frustrations in our work, and the machinations of our enemies matter ever so slightly less. We regain composure not by being made to feel more important, but by being reminded of the minuscule and momentary nature of everyone and everything.

As our eyes wander over the vast grey swell of the sea, we are immersed an attitude of gratifying indifference to ourselves and to everything about our laughably insignificant fate. The waters of time will close over us, and it will – thankfully – be as if we had never lived.

Conclusion

Works of culture can redeem us in a variety of ways, but we should never overlook the fact that they can do so only on one condition: that they are successful as works of art. It isn't enough that they should badly want to help us, that they should have powerful intentions to be companionable, serene or inspiring. They must also be these things in and of themselves. In other words, they cannot be mere manifestoes or declarations; they must, in addition, be good art.

That we need good art in the first place has to do with one of the deepest troubles of the human condition: we are generally committed to rejecting or ignoring all good advice unless we have first been extremely skilfully charmed or seduced into accepting it. The point was memorably elaborated on in the early nineteenth century by the German philosopher Hegel, who was deeply struck by the way in which good advice usually doesn't cut through into our lives. Extremely wise ideas have, since the beginning of time, been offered to humanity. The argument for kindness rather than cruelty or the long-term over the short-term have been won long ago in the pages of serious philosophical texts. But, as Hegel was painfully conscious, this has never in itself had much impact on how we actually behave. What counts, he

realised, isn't simply the message, but also the medium.

And, he concluded, the very best medium for imparting ideas is good art. In his *Lectures on Aesthetics* (1835), Hegel suggested that the best art has the capacity to present important ideas in a seductive, captivating form. As he formulated it, art is the sensuous presentation of ideas. Sensuousness – beauty, lustre, charm, playfulness, wit – is no mere incidental add-on, it is what makes the difference between a message lodging in our minds and flitting straight in and out again.

Hegel had particular admiration for how the ancient Greeks hadn't restricted themselves to presenting their ideas as philosophy. They had managed to give them a more compelling form, as theatre, set to music, or sculpted out of stone. So for example, Apollo may have been the god of wisdom, but in order that his wisdom be remembered and adhered to, the Greeks had grasped that he needed a pleasing, and even at points physically enticing, outward form; that his hair had to be thick, his muscles akin to those of a great wrestler and his cloak teasingly drawn back (*overleaf*). Only then would his wisdom emerge as properly believable.

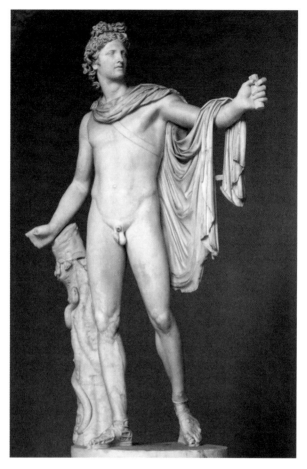

Wisdom embodied in a sensuous form
After Leochares,
Apollo Belvedere,
c. 120–40 AD

A great artist isn't, therefore, just someone who sets out to help us live and die well. It is someone who knows how to seduce us into wisdom, so that we are at once instructed, entertained, charmed and gripped.

We need culture around us because we are so poor at retaining our equilibrium and maturity. The best lessons are constantly draining from us. We must have the right songs, films, history books, plays and images to hand to keep us from succumbing to rage and error. Culture is our emotional apothecary, a storehouse of humanity's finest bottled wisdom and compassion, with whose help we have the best chance of riding out our many inevitable moments of fragility and folly.

Credits

Introduction
p.9 Rogier van der Weyden, *The Descent from the Cross*, before 1443. Oil on panel, 204.5 x 261.5 cm. Museo del Prado, Madrid.

Companionship
p.18 Anselm Kiefer, *Alkahest*, 2011. Oil, emulsion, acrylic, shellac, chalk, lead and glass on canvas 280 x 380 x 19 cm. Courtesy Galerie Thaddaeus Ropac, London • Paris • Salzburg © Anselm Kiefer. Photo: Ulrich Ghezzi. p.21 Jean-Baptiste-Camille Corot, *The Leaning Tree Trunk*, c. 1860-65. Oil on canvas, lined, 49.7 x 60.7 cm © The National Gallery, London. Salting Bequest, 1910. p.27 Henri Matisse, *Woman Reading at a Small Table*, c. 1923. Photo: Archives H. Matisse, all rights reserved. Artwork: © Succession H. Matisse/ DACS 2018. p.29 Christen Købke, *A View of Østerbro from Dosseringen*, 1838. Oil on canvas, 39.5 × 50.5 cm. Museum Oskar Reinhart. National Gallery of Denmark. p.32 Andrea del Verrocchio, *Tobias and the Angel*, c. 1470–5. Tempera on poplar wood, 83.6 x 66 cm, The National Gallery, London.

Hope
p.37 Claude Monet, *Poppies*, 1873. Oil on canvas, H.50 x W.65 cm. Granger Historical Picture Archive / Alamy Stock Photo. p.38 Pierre-Auguste Renoir *Picnic (Le Déjeuner sur l'herbe)*, c. 1893. Oil on canvas, overall: 21 1/4 x 25 11/16 in. (54 x 65.3 cm). BF567. Barnes Foundation. p.41 Bernard van Orley (workshop of), *Virgin and Child*, 1640–99. Oil on canvas, H. 73.3 cm × W. 62 cm × T. 3.2 cm × D. 9 cm, Rijksmuseum Amsterdam. p.44 (top) Vincent van Gogh, *Still Life: Vase with Pink Roses*, 1890. Oil on canvas, 71 × 90 cm. (bottom) Vincent van Gogh, *Self-Portrait with Bandaged Ear*, 1889. Oil on canvas, 60 cm × 49 cm. Archivart / Alamy Stock Photo.

Balance
p.52 Mel Gibson, *Braveheart* (1995). Moviestore collection Ltd / Alamy Stock Photo. p.54 John Pawson: The Life House, Wales, 2011–16. John Pawson. p.55 Borromini: San Carlo alle Quattro Fontane, Rome, 1638–41. Vladimir Khirman / Alamy Stock Photo. p.56 (top) Jacques-Louis David, *The Oath of the Horatii*, 1784. Oil on canvas. 329.8 cm × 424.8 cm. (bottom) Edmund Leighton, *The End of The Song*, 1902. Oil on canvas, 128.52 × 147.32 cm.

Encouragement
p.83 George Du Maurier, 'The Six-Mark Tea-pot', *Punch* (1880). © Heidelberg University Library. p.85 Traditional ceramic tea bowl. Sino Images/Getty Images. p.86 Louis Kahn, National Assembly Building, Dhaka, 1970. Muhammad Mostafigur Rahman / Alamy Stock Photo.

Appreciation
p.91 David Hockney, *Three Trees near Thixendale, Summer, 2007* Oil on 8 canvases (36 x 48 in. each) 72 1/4 x 192 3/4 in. overall © David Hockney. Photo Credit: Richard Schmidt. p.92 (top left) Albrecht Dürer, *Great Piece of Turf*, 1503. Watercolour, pen and ink. 40.3 cm × 31.1 cm. (top right) Pierre Bonnard, *Woman with Dog*, 1922. Oil on canvas, 69 x 39 cm. Sterling and Francine Clark Art Institute, Williamstown, Massachusetts, USA / Bridgeman Images. (bottom) Mary Cassatt, *Mother Playing with her Child*, 1899. Pastel on wove paper, mounted on cardboard, 64.8 x 80 cm © 2000–17 The Metropolitan Museum of Art. All rights reserved. p.94 Vanessa Bell, *Interior with the Artist's Daughter*, c. 1935–36. From the collection of the Charleston Trust. Copyright the Estate of Vanessa Bell, courtesy of Henrietta Garnett.

Perspective
p.102 Hiroshi Sugimoto, *Atlantic Ocean, Martha's Vineyard*, 1986. Gelatin silver print, 50.8 x 61 cm. Courtesy of artist / Fraenkel Gallery.

Conclusion
p.108 after Leochares, *Apollo Belvedere*, c. 120–40 AD. Copy of bronze original of ca. 350–25 BC. White marble. Vatican Museums, Musei Vaticani, Vatican City.

The School of Life is dedicated to developing emotional intelligence – believing that a range of our most persistent problems are created by a lack of self-understanding, compassion and communication. We operate from ten physical campuses around the world, including London, Amsterdam, Seoul and Melbourne. We produce films, run classes, offer therapy and make a range of psychological products. **The School of Life Press** publishes books on the most important issues of emotional life. Our titles are designed to entertain, educate, console and transform.